Let's go to that house, for the linen looks white, and smells of lavender, and I long to be in a pair of sheets that smell so.

— Izaak Walton

Ex Libris

The
Linen
Closet

And still she slept on
in azure-lidded sleep,
In blanched linen,
smooth and
lavender'd.

— JOHN KEATS

The Linen Closet

HOW TO CARE FOR
YOUR FINE LINENS AND
LACE

MICHELE DURKSON CLISE

CHRONICLE BOOKS
SAN FRANCISCO

A word in the beginning. Linen ought to be for use, not for show. Better the simplest cloths fresh from the laundry, even if something frayed, than the richest damask yellow with long lying. Indeed, it ought to be a cardinal rule in every home that the silver, linen, and fine manners are to be used every day. Use brightens and whitens all three, and does not wear them anything like so much as lying in wait for company.

— EMILY HOLT, *THE COMPLETE HOUSEKEEPER*

Introduction

For as long as I can recall, I have associated comfort and security with sweetly scented linens, starched curtains, and piles of damask napkins neatly pressed and folded.

I can remember my mother patiently explaining the whys and hows of caring for her beautiful household linens. Helping her hang newly washed sheets on the clothesline, and hearing them snap dry in the wind, was a task met with anticipation and pleasure. Gathering our fresh, clean laundry is a part of this same wonderful memory I still cherish.

I came to feel a sense of accomplishment in gliding an iron over a freshly laundered curtain, pillowcase, or tablecloth. After our work was done, and the linens tidily arranged in a closet scented with lavender, we felt we had completed a satisfying task that enhanced the comfort of everyday life.

Throughout my childhood I became more and more enamored with old linens, and was captivated by the patterns and designs to be found on them. Flowers of every garden variety, as well as shamrocks, trefoils, and polka dots, were woven into this lustrous and durable fabric. An abundance of trimmings and insets—ruffles, cutwork, scalloped edges—were lavished on these already lovely pieces.

As I grew older I began to acquire my own collection. Pieces would come from family and friends, flea markets, antique and specialty linen shops, and estate sales. Soon I had baskets, hat boxes, and drawers overflowing with items of all description.

I came to take great pleasure in caring for and preserving my linens. As time went on, I accumulated valuable advice and time-honored techniques from a variety of sources in the United States and Europe.

Even now, in an era of of modern conveniences and very little leisure, I continue to care for my own linens and firmly resist sending them to a commercial dry cleaner. The thought of Aunt Vita's cutwork table runner being shredded by commercial laundry equipment, or even lost, is unbearable to me. No amount of money that might be tendered as repayment can replace a special piece.

I urge you to care for your own pieces as well. These beautiful older linens, lace, and embroidered goods are becoming more and more scarce. If you are fortunate enough to have acquired a vintage piece, consider it a rare treasure. The quality of the thread and the density of the handwork can no longer be duplicated. And the soft lustrous sheen is the result of years of loving use and care.

There is still some new linen handwork being produced outside the United States. These pieces are quite lovely and, if cared for properly, will become even lovelier as they age. I believe that this handwork is a vanishing art.

However few or many linens you acquire, I urge you to give them thoughtful attention. Whether you have just a small vintage doily or an elaborate new bed collection, your care and concern will help preserve these beautiful pieces so that they may be enjoyed well into the future.

Now find a comfortable chair to curl up in with your book, and peruse it at your leisure. You will soon see that the knowledge contained on these pages is mostly common sense, plus some helpful specifics about washing, ironing, and storing. When you are ready, gather together your linens in your old wicker laundry basket. Set up your ironing board in a quiet, well-lighted room. Set aside some pretty ribbons and sweet-smelling lavender, as well as clean white cloths for storage. Soon you will know the satisfaction and gratification that come from nurturing and preserving these beautifully crafted and universally comforting objects.

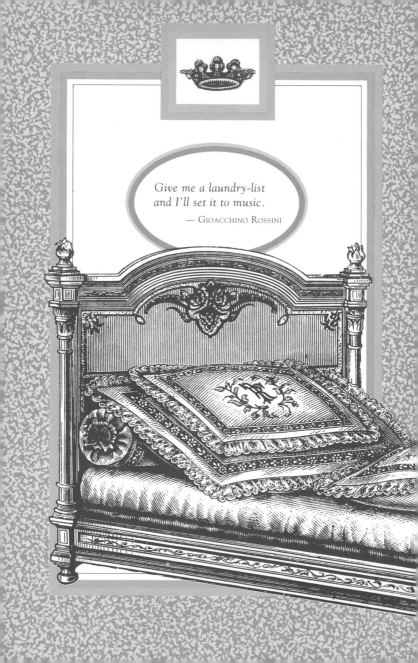

*Give me a laundry-list
and I'll set it to music.*
— GIOACCHINO ROSSINI

Washing

Washing your linens can be a pleasurable task, and you shouldn't feel intimidated by the thought of laundering your prized pieces. I generally don't entrust my own linens to commercial cleaners. I would rather care for them myself than risk having them damaged or lost.

First determine which pieces can be machine washed and which need to be washed by hand. Antique whites made of cotton or linen that aren't trimmed with lace can be machine washed. I launder my damask tablecloths, runners or napkins, and vintage bedding on a gentle cycle in hot water with regular soap or enzyme detergent.

Lacy or fragile items should be hand washed in warm water with a gentle soap such as Ivory Flakes or Orvus, a non-detergent cleanser commonly used for old textiles. I prefer to hand wash smaller items, such as my lace-trimmed pillowcases, sham covers, hand towels, place mats, and cutwork table runners, as well as my larger lace curtains. It is advisable to place those items in a net laundry bag or an old pillowcase. If you use a pillowcase, tie the end with a piece of white fabric or even a white or colorfast ribbon.

Frequent but mild cleansing is best. Pre-soaking in cold, then hot water is essential for extremely soiled items. You would never want to use a chlorine bleach as it weakens fibers and can even facilitate disintegration. A non-chlorine bleach may be used sparingly, but it doesn't remove soil and shouldn't be considered a substitute for washing.

Consider the wash basin or bathtub a good place to hand wash linens, but leave plenty of room so that

O Bed! O bed!
delicious bed!
That heaven upon earth
to the weary head.
— THOMAS HOOD

water currents can be created by swishing items around and suds can be squeezed through the fabric. Make sure the water is hot enough to dissolve the soap. And most importantly, rinse thoroughly afterward. A poor rinsing can undo the most efficient washing and can even cause damage by leaving residue that will scorch when ironed or turn yellow with time. So, rinse three times with lots of hot water.

The same advice applies to machine washing. Leave plenty of room in the washtub to allow for water currents. Make sure the water temperature is hot enough to dissolve the soap. Rinse thoroughly.

Stains on linen and lace are bound to occur and should be regarded as only a small mishap. It is important to note that stains should be removed before washing, not during or after. See the following pages for detailed instructions on stain removal.

*The bed has become
a place of luxury to me!
I would not exchange it for
all the thrones in the world.*

— NAPOLEON I

Removing Stains

No gracious hostess would disrupt a dinner party were red wine spilled on her heirloom tablecloth. However, a stain should be treated as soon as possible to limit damage and ensure easy removal. And, with rare exception, stains should be removed before washing, not during or after.

Each kind of stain calls for a different treatment. What works for grease may very well not work on something else. The best chance you have for preserving your precious linens is knowing what to use and how to apply it. I have met with great success in removing stains over the years and, with a little knowledge, so can you. Here is a list of common stains and ways to remove them from linens.

Berries and Fruit

Sprinkle wet stains with salt and rub with damp soap. After a few hours, rinse well. If the fabric is strong, stretch the stained area over a bowl and pour a stream of boiling water through it from a height of two to three feet until the stain disappears. A borax and water solution will sometimes help dried stains; mix one part borax with six parts water and soak.

Blood

There are several ways to remove blood stains, all of which initially use cold water. Never attempt to use hot water to remove blood as it will set the stain. Wash immediately or as soon as possible with cold water. If the stain is very bad, soak in cold, salted water before washing as usual.

Candle Wax

Harden the wax with an ice cube, then gently flake it away. Place the item between sheets of clean brown paper and press a warm iron over the paper, moving the paper as wax is absorbed. If the stains have been caused by colored wax, try dipping a sponge in rubbing alcohol and dabbing before washing. Colored wax stains are best treated by a professional.

Chocolate

Stains that have occurred in sturdy linen or damask should be covered with dry borax, then washed in cold water. Stains that have occurred on delicate fabrics should be sponged with warm water, while rinsing the sponge repeatedly.

Coffee and Tea

If the stains can be treated immediately, apply a borax solution of one part borax to six parts water. Wash in warm, soapy water. Treat stains that have dried with a mix of one part glycerine, one part water to loosen them. To remove stubborn stains on sturdy fabrics, stretch the stained area over a bowl and pour a stream of boiling water through it from a height of two to three feet until the stain disappears.

Grease

These stains are best treated while still fresh. If the stain can be treated immediately, sprinkle baking soda on it and leave for a few hours. Brush off the baking soda and wash the piece. If the grease has dried, soak a white cloth in alcohol and spot clean.

Mildew

Wash with hot, soapy water. If the fabric is white, then apply a paste of lemon juice and salt, rinsing before it dries. Dry in the sun.

Rust

Rub brown rust spots on vintage whites with a paste of lemon juice and salt. Rinse and repeat several times if necessary. Wash in hot soapy water.

Scorch Marks

Wash in hot, soapy water. If the fabric is white, first apply a paste of lemon juice and salt, rinsing immediately. Or soak in a borax solution of one part borax to six parts warm water before laundering.

Wine

Most white wine stains will come out in a hot soapy washing. To remove red wine, sprinkle salt on it and put the item in cold water. If it remains, try to rub it out with salt before washing. Saturating a stain with club soda or a solution of baking soda and water will often remove it.

Remember that stains should be removed as quickly as possible and, in almost all cases, before laundering, not during or after. You may find it extremely helpful to keep these instructions close at hand for quick and easy reference. Also, it is a good idea to have the following stain removal agents in your home: baking soda, brown paper, club soda, cornstarch, enzyme (biological) detergent, glycerine, household borax, lemons, rubbing alchohol, and salt.

Starching

Putting a fresh, crisp finish on your linens will enhance their own natural gloss. I find that line drying gives many of my pieces enough stiffness to make starching unnecessary. However, a light application of starch, combined with a good ironing, creates a smooth, lustrous sheen and a crisp shape. It can also make subsequent washings easier, because a thin layer of starch helps protect the fabric from soil. I starch my linens every third wash.

I dislike commercial spray starch because it scorches easily and plugs the iron. I prefer the old-fashioned method, which is less costly and ensures a smooth, even finish. If you do not have a favorite starch recipe, I suggest using my Aunt Pat's formula.

She is an English woman who specializes in collecting and selling vintage linens.

Mix one rounded tablespoon of starch powder with two tablespoons of cold water into a smooth cream. Add one and a half pints of vigorously boiling water, and stir briskly until the mixture is uniform. Dilute as necessary.

If you prefer, the gloss of the table linen can be heightened by blending one teaspoon of powdered borax with the starch powder.

Dampen the linen and immerse it in the starch, then carefully squeeze out the excess starch before drying. The amount of starch used depends largely on the use of the item. Naturally you would want your table linens to be crisper than your bedding.

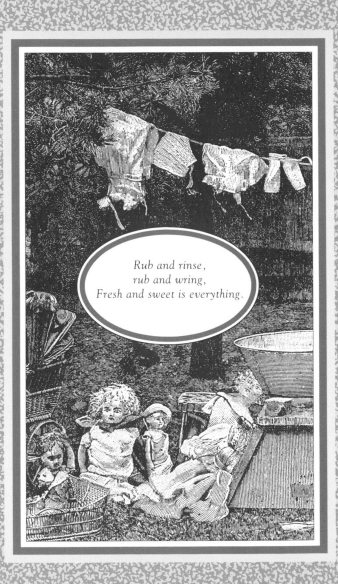

Rub and rinse,
rub and wring,
Fresh and sweet is everything.

Drying

If your dryer has a low-heat, low-tumble cycle, you might choose to dry sturdier linens by machine.

I prefer to line dry my linens. Whenever possible, I hang the wash outside because nothing compares with the clean scent of bed linens and tablecloths dried in sunshine and fresh air.

If you have no outdoor clothesline, an indoor line in the laundry room, a shower rod, or a retractable line over the bathtub will work well.

If you do use a shower rod, place only one or two sheets or large cloths on it at a time. Also, terry towels placed where the tub meets the floor will catch excess water that drips.

A tension line or rope pulled through hooks on an outside balcony is sometimes possible, or a collapsible drying stand. Drying stands made of wood or plastic-covered metal can usually be purchased at a good hardware or housewares store, or from a catalogue that specializes in closet accessories.

To make ironing easier, lightly shake out linens before hanging them. Fold square or rectangular

items neatly over the line. Secure them with clothespins at the strongest places, not at the corners. An easy method is to fold sheets in half and hang them by their hems. For faster drying, drape sheets between two parallel clotheslines and pin them evenly by their hems. It is a wise idea to hang only one or two heavy articles on a single line. And always handle wet linens carefully, because the weight of the water can rip their fibers.

Ironing

The next step is ironing. If you are not going to be using your linens for some time, they should be stored away unstarched and unironed. It is best to roll them in clean, white cloths, tucking or tying ends together. Or you may wrap them in acid-free tissue, which can be purchased from a museum or a textile store.

To ensure successful and easy ironing, it is necessary to first 'season' the linens. This is a simple process of sprinkling the fabric with hot water, rolling it up in a clean, white cloth, and setting it aside for several hours. Seasoning makes the linen fibers much more pliable.

To sprinkle, spread your linens on a clean table or counter top. A spray or sprinkler bottle will distribute the water—which should be hot—evenly. This prevents a blotchy finish. You may also use a small, clean whisk broom or the tips of your fingers. Dip either into a bowl of hot water and shake fine drops all over the linens. Dampen with a light touch and in an even manner.

When you are through, roll up the dampened linens in a cloth and leave them for an hour or more

— overnight is best. Keeping them in the refrigerator during this time will make ironing even easier.

Don't wait longer than twenty-four hours before ironing your seasoned linens, because bundling damp cloth creates a perfect breeding ground for mildew. This fungus, always present in the air, develops rapidly in heat and darkness. It causes a sour odor and greyish brown stains, which can sometimes be removed with soap and water. Naturally it is best to prevent their formation in the first place.

When I am delayed from ironing for a brief time, I store batches in the refrigerator. For longer periods of time, I wrap linens tightly in a plastic bag and put them in the freezer. After returning to room temperature, these pieces are perfectly prepared for ironing. Note: If you find you cannot do this, simply unroll the linens and leave them to dry. Resprinkle at another time.

After you have seasoned and ironed a few times, you will come to know just how much dampness is needed to enable the iron to glide.

Now set up your ironing board in a cheerful, well-lighted room of your home. A large clean sheet placed under the ironing board will protect larger pieces draped on your board, as well as smaller pieces that may fall to the floor.

Try to think of this as a relaxing time in which you are going to start and finish a project that will be very rewarding. For so little of your effort, a lovely piece of work emerges that will ultimately enhance your home as well as nourish a tradition of handwork.

It is best to use an ironing board that has been padded with one or two layers of flannel or blanket over which you have tautly pinned fine, unbleached muslin or a clean used sheet.

Your iron should be very clean. Flush it thoroughly with a vinegar and water solution to remove any minerals that may have accumulated over time. Be sure the soleplate is clean and smooth. If it is sticky from starch residue, lay a little fine salt on a flat surface and rub the iron over it.

Although you will find high temperatures most effective for ironing your linens, take care not to scorch them. If the fabric hisses under the iron, the piece is too wet.

If you are right handed, work from right to left. When ironing small items the square end of the board will be closest to the plug, on your right side. For larger pieces, turn the board in the reverse direction so you'll have a larger square surface to work on. Be sure the cord can move freely so that it doesn't become entangled. When ironing larger pieces, you

will find that a heavy-duty extension cord is easier to maneuver.

Padding and pinning a square table for use as an ironing surface will allow you to work from all sides. If you have a lot of ironing to do, this endeavor will be worth your while. Be sure to use a longer cord.

Keep your iron moving to avoid scorching fabrics. If you are working on delicate laces or nets, use a white pressing cloth. Repeatedly lift and press down the iron until the entire piece has been covered. Pressing cloths made from old handkerchiefs or hand towels do very nicely for small items, such as lace collars or bits of lace. Old cotton sheets are excellent for use on larger pieces.

Fabrics with raised embroidery or eyelets should be ironed face down on a thick towel so as not to flatten the handwork. Then press carefully on the reverse side.

When you are finished, be sure to air dry your freshly pressed items before you fold or store them. This will prevent the growth of mildew. Larger pieces should be dried for at least twelve hours before storing.

First your iron smooth must be,
Rub away! Rub away!
Rust and iron disagree, Rub away! Rub away!
Tho' your iron must be hot,
Glide away! Slide away!
It must never scorch or spot,
Glide away! Slide away!
Then the cloth, so soft and white,
Press away! Press away!
On the table must be tight,
Press away! Press away!
Crease or wrinkle must not be,
Smooth away! Smooth away!
Or the work is spoiled, you see,
Smooth away! Smooth away!
Ev'ry piece, when press'd with care,
Work away! Work away!
Must be hung a-while to air,
Work away! Work away!
Then you fold them one by one,
Put away! Put away!
Now the ironing is done,
Happy day! Happy day!

—BESSIE HILL AND SAMUEL WARREN, 1885

OUR PET

IT MAKES A
DELICIOUS D...
WITH ...

Lace Curtains

All lace curtains and thin fabrics such as net or muslin should be shaken free of dust, then washed gently in warm suds. Starch lightly, if at all, while still wet, and dry them as straight as possible. True lace curtains should be pinned on sheets laid on the floor. You will find this to be time consuming, but well worth the effort. Pin the curtains square at their corners first, then stretch and pin the pattern in line with the edges. When the curtain is secured, pat it firmly with a damp cloth to remove any excess starch, if you have starched. Be sure to use non-rusting pins.

When space has been limited, I have had success drying my large lace panels on the shower rod. This has a soft roll on which the curtains rest, and I carefully arrange panels in an even way so that they will need only a light touch with the iron. I have done lace canopies, bedspreads, and even a wedding veil this way.

Always press your lace curtains with the lengthwise threads, just as you must always iron on the straight of your linens, never on the bias. This will help to retain the shape of your curtains and prevent puckering and rippling. Hang your pressed curtains as soon as possible or drape them carefully over a large table or bed until you are ready to hang them.

Washing Lace

True antique lace is valuable and should be treated only by a professional. You will find that silk lace also responds better to professional care. Other kinds of lace that are made of natural fibers can benefit from your own tender, loving attention. If you are in possession of musty, stained pieces that have languished in an attic or antiques shop for a long time, you can restore them to their former beauty by gentle washing and shaping.

Advice on washing lace varies, but one constant prevails—handle your lace with the utmost care! Before washing, trace a template of the shape of the lace item on paper and use it to return the lace to its original shape while it is drying. Be sure to remove all your hand jewelry before cleaning these lovely, delicate pieces.

A dingy bit of lace should first be soaked in cold water for at least an hour. To launder smaller items, fill a large wide-neck jar half full of warm, soapy water. Drop in the lace, screw on the top, and gently

shake the jar until the lace is clean. Rinse the same way, changing the water at least three times. If the net threads are brittle, add a teaspoon of olive oil to the water when washing and rinsing.

Larger lace items can be placed in net bags designed for cleaning lingerie, then squeezed gently by hand through soapy water. A backing of white cloth can be lightly stitched to the lace to help preserve its shape and to lend stability while washing. Again, rinse thoroughly.

Lay the wet lace on a fluffy towel, reshaping it; or pin it over the template, which has been placed on a clean, padded surface. Use non-rusting pins only, and avoid damage to threads by inserting the pins only through openings in the net.

Gently press the still-damp lace with the raised side down on a padded surface. Use a cool to medium iron with a slightly dampened pressing cloth. If the lace has dried completely, carefully season it with a fine mist and wrap it in a towel for several hours before pressing. Allow twelve hours for air drying before storing or mending lace.

PINCUSHION.

Mending

Restoring vintage linen or lace to its former beauty sometimes requires mending. The old homily that a stitch in time saves nine is advice well taken.

When I mend fragile textiles, I don't expect my repairs to be invisible, particularly on work with a net ground. Even when professionally done, repairs will often be visible. But careful mending can improve and help preserve slightly torn pieces.

Always mend, or at least secure loose ends, before washing an item. If you discover the tear after laundering your fabric, mend it before ironing. Linen or lace that is going to be stored should at least have loose ends secured until there is time for mending. This will prevent larger holes or more unravelling. If you have a valuable piece that needs repair, and a simple patch or tiny darning stitches will not suffice, I encourage you to use the services of a professional. Linens Limited of Milwaukee consider themselves experts. Their address and phone number are listed at the back of this book.

Tinting

The beauty of vintage lace can be enhanced immeasurably by the old-fashioned method of tea dyeing. This lends a lovely pale ecru color to lace and is an excellent way to refresh and revive pieces that have become discolored.

The lace to be dyed must be clean and, if necessary, mended. First saturate it in cold water as this will ensure an even distribution of color. Have a solution of cold tea prepared. Dip the lace in it—gradually and sparingly.

I always begin with single pale immersions—then dry, inspect, and repeat the process if a darker effect is desired.

If you have never done any tinting, I suggest you experiment with pieces of an old cotton sheet or any old hankie or bits of lace you may have. This will allow you to gain confidence before you dye your good pieces. Remember that each item will take color differently, so proceed carefully, keeping colors pale. You can always immerse again.

A hint: Some authorities on vintage tea dyeing suggest adding a few drops of ink to the cold tea solution.

Storage

If you are going to be storing linens for an extended length of time, it is best to wrap them—laundered and unstarched—in a clean cotton cloth. Never use plastic, polyurethane, or colored bags to store white linen because these materials can trap undesirable moisture, inviting mildew and even the transfer of color. Acid-free tissue is often recommended, but I prefer old white cotton or linen sheets and tablecloths. They make sturdy, washable, and reusable storage wrappers.

Do not ever store soiled linens. Stains will set if not treated promptly and will be more difficult to remove later. Ironing linens that are going to be stored for an extended length of time is not a good idea either, as fabric rot can grow along the creases. Instead, gently roll large pieces. Tablecloths, sheets, and other larger items can be softly folded on hangers padded with soft material, then covered with clean cloths and hung in the closet. I find that gently rolling my linens is a good way to prevent creases.

Linen closet shelves should be clean and completely free of dust. I always enjoy a linen closet that smells fresh as well. Leave the door ajar so that air can circulate, and place scented soap, a pomander

ball, or a sachet near your spotless napery and bedding. Beware of cedar chests and closets. Both the fumes and the contact with the wood will discolor whites.

It's a good idea to unroll and check rarely used items several times a year. A brief inspection for any possible deterioration, followed by an hour of fresh air and sunshine, will help prolong the lives of these lovely objects.

A tip for storing table linens: Find a large cardboard mailing tube as long as the width of the tablecloth. Wrap a clean cotton cloth around it. Attach a narrow ribbon inside the tube, leaving one yard on each end. When the cloth is pressed smooth, roll it around the tube and fasten it in place by tying the ribbons.

Scenting

I think there is nothing so nice as sweetly scented linens. By sweet I mean with just a hint of delicate lavender, rose, or a true, old-fashioned potpourri. Personally, I prefer lavender.

Real lavender is a clean, pure scent that mixes well with other aromas. This wonderful herb has long been used to scent linens because it retains its freshness and fragrance. Sachet bags filled with lavender need just a gentle squeeze now and then to renew their scent.

Rose-petal sachets also give linen an exquisitely delicate fragrance. One recipe calls for gathering freshly opened petals, drying them in the shade, and, once they are thoroughly dry, mixing with dry lemon peel and calamus root—both grated—amounting to half the bulk of the petals.

For a spice fragrance, gather and dry rose petals. Then pound in a mortar a small quantity of cloves, caraway seeds, and allspice. Mix all together, adding a little salt, and sew into small white silk bags. Tie with a narrow silk ribbon.

Making a pouch for these ingredients does not require any sewing. A lovely linen or lace handkerchief or a piece of pretty fabric will do nicely. First cut out a circle or square, then pink the edges. Put some of the mixture into the center, gather the sides, and secure with a grosgrain ribbon.

These are just a few of the many ways to scent your treasures. Some collectors hang ribbon-tied bundles of lavender sticks by their linens. Others tie their favorite potpourri in a lace handkerchief to perfume a linen drawer or closet. My grandmother used rose petals in her potpourri, and I always associate this delicate scent with her beautiful linens.

Making Lavender Sticks

To make your own lavender sticks, gather the lavender before the flowers have blown. The stalks should be fresh and green so that they won't break easily when you handle them. Take about twenty-one stalks (an odd number) of lavender and first remove the leaves and buds that grow beneath the heads. Place the stalks evenly together, and tie a long, very narrow ribbon tightly around them just under the heads, making a bow. Leave about an extra two yards of ribbon.

Next, bend the stalks back on themselves to cover the heads of lavender. Weave the ribbon tightly

through the bundle of stalks in a spiral, alternately putting it over two stalks and under two, until the heads are covered. Now cut the end of the ribbon off, leaving just enough to tuck among the heads of lavender. To secure the bundle, tie a second ribbon tightly in a bow around the stalks about two inches from the first ribbon. (Fig. 1)

An even simpler way to make a lavender bundle is to tie a ribbon under the heads in the same way as before, bend the stalks over, place them evenly around the heads, and tie the second ribbon around the bundle about two inches from the first—omitting the weaving altogether. (Fig. 2)

A History of Your Collection

Your new linens will become legacies one day, just as your vintage linens are part of a continuing legacy. I encourage you, as you acquire these beautiful treasures, to keep a record of them. Christening dresses, baby bonnets, wedding veils, bed linens, damask table linens, handkerchiefs, hand towels, and scraps of lace are all precious artifacts with fascinating histories of their own.

It is only appropriate that, as you lovingly maintain your old and new pieces, a little bit of their history is preserved as well. Valuable information such as the age of the piece, the kind of lace attached to it, its country of origin, or its previous owner can

then be passed on to others who may become the fortunate keepers of these treasures. And, it will serve to remind you of the pleasant friends and happy times that were a part of acquiring them.

This history of your linen and lace treasures also validates and conserves their value. It will be of interest to anyone who inherits these beautifully handcrafted pieces and will also be helpful for insurance purposes. Linens and lace, when properly cared for, increase in value and merit insuring.

The next several pages have been designed for you to record and preserve information about your collection. By doing so I hope you will discover the pleasure of becoming the trustee of a little history.

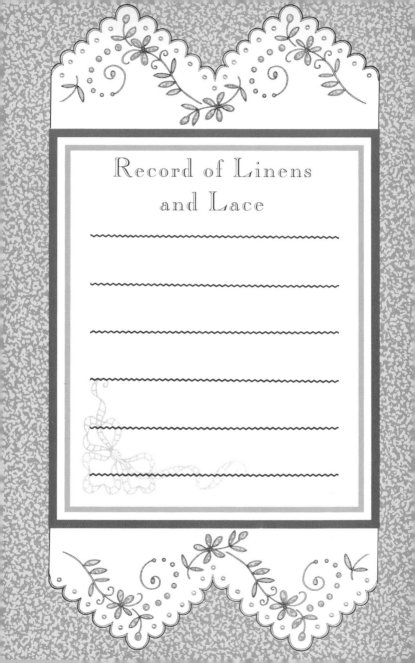

Record of Linens
and Lace

~~~~~~~~~~~~~~~~~~~~~~~~~~~~~~~~~~~~~~

~~~~~~~~~~~~~~~~~~~~~~~~~~~~~~~~~~~~~~

~~~~~~~~~~~~~~~~~~~~~~~~~~~~~~~~~~~~~~

~~~~~~~~~~~~~~~~~~~~~~~~~~~~~~~~~~~~~~

~~~~~~~~~~~~~~~~~~~~~~~~~~~~~~~~~~~~~~

~~~~~~~~~~~~~~~~~~~~~~~~~~~~~~~~~~~~~~

Record of Linens and Lace

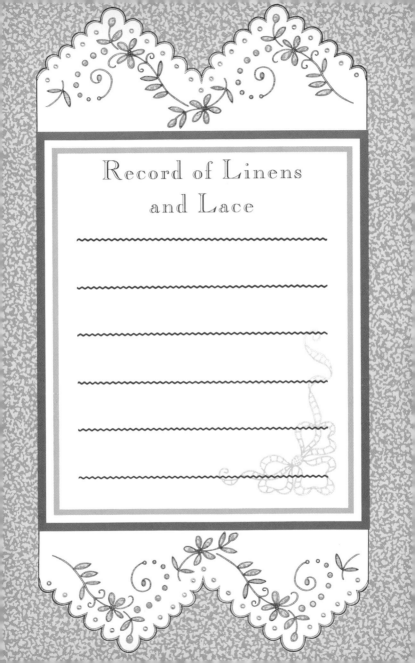

Record of Linens
and Lace

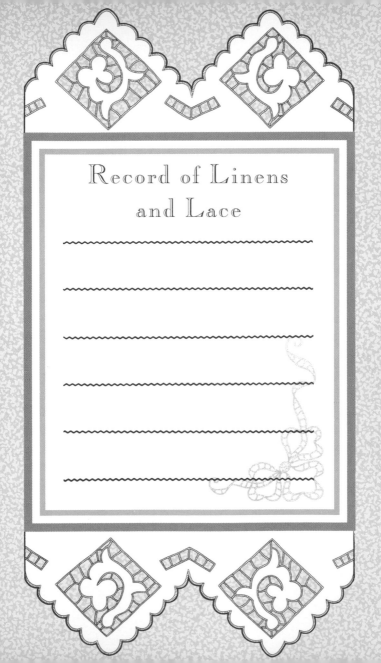

Record of Linens
and Lace

~~~~~~~~~~~~~~~~~~~~~~~~~~~~~~~~~~~~~~~~~~~~~~~~~~~~~~~

~~~~~~~~~~~~~~~~~~~~~~~~~~~~~~~~~~~~~~~~~~~~~~~~~~~~~~~

~~~~~~~~~~~~~~~~~~~~~~~~~~~~~~~~~~~~~~~~~~~~~~~~~~~~~~~

~~~~~~~~~~~~~~~~~~~~~~~~~~~~~~~~~~~~~~~~~~~~~~~~~~~~~~~

~~~~~~~~~~~~~~~~~~~~~~~~~~~~~~~~~~~~~~~~~~~~~~~~~~~~~~~

~~~~~~~~~~~~~~~~~~~~~~~~~~~~~~~~~~~~~~~~~~~~~~~~~~~~~~~

Record of Linens and Lace

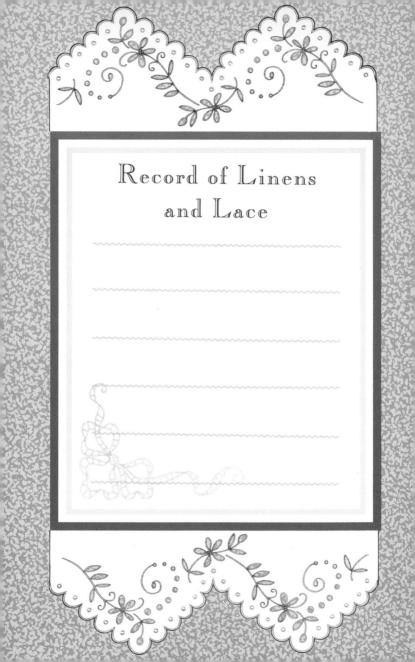

Record of Linens
and Lace

~~~~~~~~~~~~~~~~~~~~~~~~~~~~~~~~~~~~~~~~~~~

~~~~~~~~~~~~~~~~~~~~~~~~~~~~~~~~~~~~~~~~~~~

~~~~~~~~~~~~~~~~~~~~~~~~~~~~~~~~~~~~~~~~~~~

~~~~~~~~~~~~~~~~~~~~~~~~~~~~~~~~~~~~~~~~~~~

~~~~~~~~~~~~~~~~~~~~~~~~~~~~~~~~~~~~~~~~~~~

~~~~~~~~~~~~~~~~~~~~~~~~~~~~~~~~~~~~~~~~~~~

For Special Problems

The Laundry at Linens Limited, Inc., of Milwaukee consider themselves experts in cleaning and restoring lace, and you may wish to contact them for information:

The Laundry at Linens Limited, Inc.
Elizabeth L. Barbatelli, President
240 North Milwaukee Street
Milwaukee, WI 53202
(800) 637-6334

Designed and produced by Marquand Books, Inc.
Printed in Hong Kong

Clise, Michele Durkson
The linen closet : how to care for your fine linens and lace / Michele
Durkson Clise.
p. cm.
ISBN 0-8118-0196-9
1. Household linens—Cleaning. 2. Household linens—Storage. 3. Lace and
lace making—Cleaning. 4. Lace and lace making—Storage. I. Title
TX315.C55 1992
746.9'6—dc20 91-35562 CIP

Distributed in Canada by Raincoast Books
112 East 3rd Avenue, Vancouver, B.C. V5T1C8

1 3 5 7 9 10 8 6 4 2

Chronicle Books
275 Fifth Street, San Francisco, California 94103